Of þe Wylde cat and o...

þe cat is a comun...

fore me nedeth no...

makynge. for felde men b...

seye sum of hem. ...ayel

uerse maneres of cattys

...ynyous and nameliche

...aly þer be sume cattys

lypardes. and som men a...

ene lowpes ceruyers, and

and hit is yuel y sayd. ff...

Cats are illustrated in manuscripts throughout the Middle Ages, often in exquisite detail and frequently accompanied by their mortal enemies, mice. They are pictured in bestiaries, natural philosophy texts and hunting manuals alongside textual descriptions of cats and other animals. But they appear more frequently as marginalia – small marginal illustrations in manuscript borders, bearing no relation to the text in question, whether theological, liturgical or romance, but simply intended to amuse and entertain the reader.

Medieval cats are depicted in all kinds of guises, from humble mousers at the hearth, to magical creatures such as the two mythological cats who drew the chariot of the Norse goddess Freyja. There are also more negative symbolic representations: in the early fourteenth century Arnold of Liege compared a cat toying with a mouse to the Devil playing with a human soul. Cats were kept as pets, admired for their wiliness and vilified for their devilish nature. They were nurtured as companions for those in religious orders, but also used in the arts of magic. And a medieval cat probably had fewer than nine lives to toy with – danger was never far around the corner, whether in the form of a fur-trader or a rowdy set of students.

A spotted wild cat in a book on hunting. *The Master of the Game* by Edward, Duke of York, England, mid-15th century. (BODL., BODLEY 546, F. 40V)

There are few recorded individual names for cats, although some Old Irish legal texts do mention some, including Méone ('Little Meow'), Cruibne ('Little Paws'), Bréone ('Little Flame', probably a ginger-coloured specimen) and Glas nenta ('Nettle Grey'). A cat is sketched in the margin of a thirteenth-century account book from Beaulieu Abbey with the name 'Mite' next to it (see illustration below). We also know of the white Pangur Bán owned by an Irish monk from his ninth-century poem of same name.

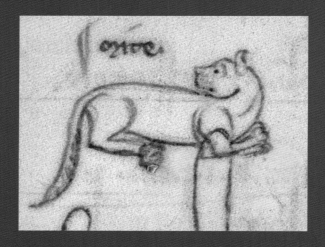

ABOVE Pen drawing of a cat accompanied by the name 'Mite'. Account book of the Cisterican abbey of Beaulieu, England, c. 1270. (BL, ADD. 48978, F. 47V)

OPPOSITE In an initial C a cat catches a mouse. Psalter, St Augustine's Abbey, Canterbury, c. 1210–20. (BODL., ASHMOLE 1525, F. 14R)

requiescet in spe.
Quoniam non derelinqs
animam meã in inferno:
nec dabis scm tuum ui
dere corruptionem.
Notas michi fecisti uias
uite: adimplebis me le
ticia cum uultu tuo: de
lectationes in dextera tu
a usq; in finem. ORATIO.
Conserua nos
famulos qs
& effice uo
luntatem tuam nobis
cum. ut clarificati. le
ticia resurrectionis tue
mereamur a dextris tu
is cum omnibus sanc
tis delectari. p.
Propheria oratio debu
militate xpi in hoc
psalmo deprimitur.

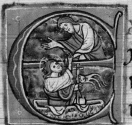

XVI

Exaudi do
mine ius
ticiam me
am: intende deprecati
onem meam.
Auribus percipe orationẽ
meã: ñ in labiis dolosis.
De uultu tuo iudiciũ
meum pdeat: oculi tu
iudeant equitates.
Probasti cor meum &
uisitasti nocte: igne
me examinasti: & nõ
est inuenta in me in
quitas.
Et non loquatur os me
um opa hominum:
ppter uerba labiorum
tuorum ego custodiui
uias duras.
Perfice gressus meos in se

'I am as melancholy as a gib cat or a lugged bear'
Falstaff in Shakespeare's *Henry IV* Part I (Act I, Scene 2)

In the Middle Ages the most common English name for a tomcat was Gyb (a shortened form of the male name Gilbert). This was a generic name, given to the entire species of domestic cat, just as sparrows were called Philip and pies called Mag. But it could also be given to an individual animal: a late fourteenth-century seal of one Gilbert Stone depicts a cat with a mouse and the legend 'GRET: WEL: GIBBE: OURE: CAT'. There is a 'Gybbe, owre grey catt' in the late fifteenth-century poem 'Leve Lystynes'.

The late fifteenth-century Scottish poet Robert Henryson, in his version of the fable of the town mouse and the country mouse (*The Taill of the Uponlandis Mous and the Burges Mous*), describes how:

> When two mice are on a table-top,
> Barely have they drunk once or twice,
> When in comes Gib Hunter, our cat.

In the same work Henryson uses the Scots name Baudrons as another generic name for a cat.

A grey striped cat holds a brown mouse in its paws. The Luttrell Psalter, England, *c.* 1325–35. (BL, ADD. 42,130, F. 190R)

mirabilia tua: non

oies multitudinis

e

uerunt ascendentes in

In the English version of the French poem
Le Roman de la Rose (*The Romance of the Rose*), the proper name of
the cat, Tibers, is translated as 'Gibbe our cat'. It is a fitting
translation as Tibers/Tibert was the equivalent generic name
for a domestic cat in French. Thus Tibert the Cat is one of the
companions of Reynard the Fox in the Reynard animal fables.
This explains why in *Romeo and Juliet* Mercutio declares to
Juliet's cousin Tybalt: 'Good King of Cats, I want to take one
of your nine lives' (Act 3, Scene 1).

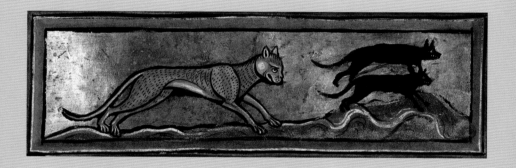

ABOVE A lithe pale orange cat chases two large mice.
Bestiary and lapidary, England, mid-13th century.
(BL, ROYAL 12 F XIII, F. 43R)

OPPOSITE In this illumination four mice turn the world
upside down and hang a cat, their habitual enemy, on the
gallows. The Rutland Psalter, England, *c.* 1250–60.
(BL, ADD. 62,925, F. 60R)

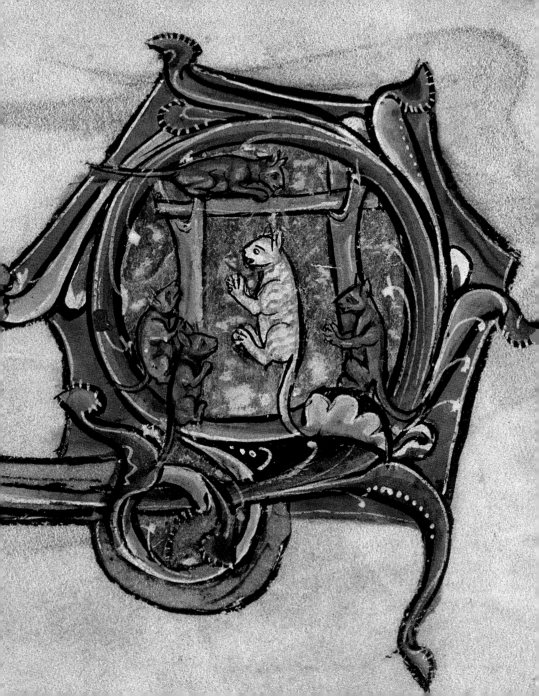

nature impio seruire parati: terra ab aliis fossam.
suprno impositam quatuor pedibz complectentes. ligne
tiuuerso locato: dentibz ab aliis hinc inde coherem
gradeq; trahentibz: n absq; intuentium admiratio

utio ap
quod r
festu fr
uulgus cacum
uocant. Alii d
captat id est u
tam acute cern
gore luminis r
nebras super.
greco uenit cat
gemosus. apo
6esz24.

us pusillum animal g
nomen est quicqd uero
hic latinu fit. Alii di
res quod ex humore tre nascam
mus tra. unde & humus. His u
mo recur crescit. sicut queda ma
augentur: que rursus minuente luna deficiunt. Sor
est eo qd rodat & in modum serre precidat. Antiqu

The economic value of cats during the medieval

period is hard to determine as they had a mixed status as mousers and occasional pets. Judging by the low cost of cat skins we can presume that it was not much. As an exception to this, cats are rated quite highly in an early medieval Irish law text called *Catślechtae* (*Cat-sections*), which values a cat as worth three cows if it could purr and hunt mice. A cat that could only purr was valued at one and a half cows, and a kitten was worth a ninth of its mother's value until it was weaned.

The tenth-century Welsh laws of Hywel Dda, king of Deheubarth, valued cats according to their age: one penny for a kitten from the night it was born until it opened its eyes; two pence for a kitten from the time it opened its eyes until it killed mice; and thereafter four pence for the same cat once it started killing mice.

ABOVE Illumination of two cats: the white one sits holding a mouse in its paws, while the dark grey one chases a black mouse that is 'escaping' from the border. Bestiary, England, early 13th century. (BL, ROYAL 12 C. XIX, F. 36R)

OPPOSITE Roundel with three cats – two grey and one orange holding a mouse – next to the word '*musio*' (cat) which opens the section on cats in this bestiary. England, mid-13th century. (BL, HARLEY 4751, F. 30V)

There is some evidence for the sale of cats. Eleanor de Montfort, Countess of Leicester, for example, purchased a cat (and some milk for her pet dogs) in February 1265 when at Odiham for two pence. But the value of a cat could sometimes be in the eye of the beholder, as seen in a 1294 court case in Chalgrave, England, which states 'William Yngeleys complains against John Saly and Christina his sister because they detain a certain cat to William's damage, which damage he would not willingly have borne for 6d'.

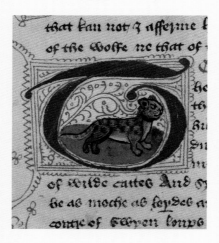

ABOVE Initial T (for 'The cat') decorated with a spotted wild cat. *The Master of the Game* by Edward, Duke of York, England, mid-15th century. (BODL., DOUCE 335, F. 26V)

OPPOSITE A seated cat and a running mouse with the Latin tags '*muriligo*' (cat) and '*mus*' (mouse) are illustrated in the left margin of this herbal. Italy, *c*. 1440. (BL, SLOANE 4016, F. 62)

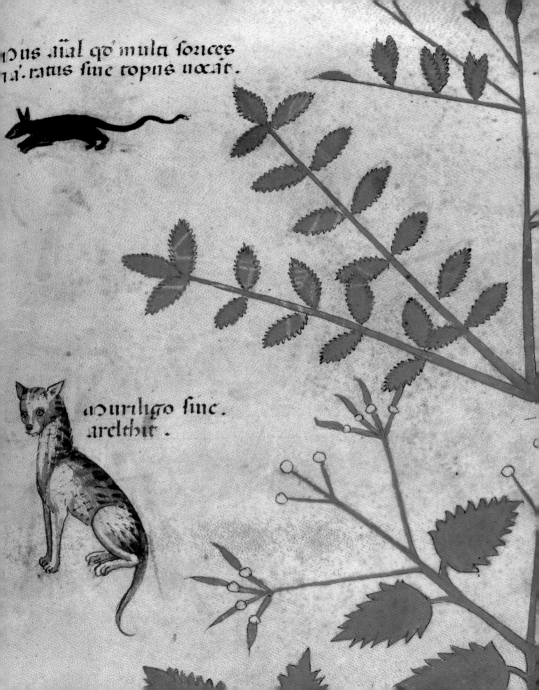

ous aïal qᵒ multa foꝛtes
ꝛaᵗ. ratus ſiue toꝑus uocaꞇ.

aꝰuriligo ſiue.
arctbit.

There are few records of food being purchased specifically for cats; they presumably feasted on the mice and rats that they caught, and possibly the occasional leftover if their owner was feeling generous. An entry in the accounts of a manor at Cuxham, Oxfordshire, in 1293–4 provides us with a rare example of special food – cheese – being bought for a cat.

Royalty could, of course, be more extravagant. The French queen, Isabeau of Bavaria, wife of Charles VI, spent a lot on her pets, such as a collar commissioned for her pet squirrel that was embroidered with pearls and fastened by a gold buckle. In her accounts there is an entry in 1406: 'For one ell of measurement of bright green cloth to make a coverlet for the cat of the Queen, sixteen shillings'.

ABOVE In this illustration for January, a young man stands by a brazier, accompanied by a cat. Janus is seated on the left. Calendar, England, mid-12th century. (BODL., BODLEY 614, F. 3R)

OPPOSITE A white cat sits with a black mouse in its mouth, accompanied by a squirrel. Breviary of Renaud de Bar, France, 1302–3. (BL, YATES THOMPSON 8, F. 178R)

quod iustum fuerit dabo uobis.

leccio. p. De teit. capitulum.

Non sumus subtraccois
filij in perditioné. sed
in acquisitionem anime in
xpo ihu domino nro. ɔ Ine̅
nium dñe. cum ℣. ut in dominica.
Domine nem̅ ua.

Cats, whether practising their mousing duties or just in residence indoors, were in close contact with their owners. By the fifteenth century many courtesy manuals claimed that it was not genteel for animals to roam around the dining hall or sit on the table, being fed by hand or patted by their owners. According to *The Boke of Curtasye* (*The Book of Courtesy*):

> Whenever thou sits to eat at the table board,
> Avoid the cat on the bare wood,
> For if thou strokes a cat or a dog,
> Thou art like an ape tied with a lump of wood.

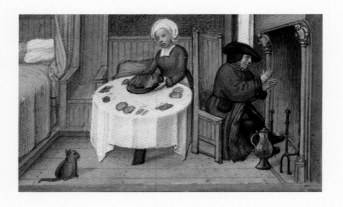

ABOVE A grey cat sits in a domestic scene, in which a woman sets the table and a man warms his arms by the fire. Calendar page for the month of January, Flemish artists, late 15th century. (BL, ADD. 35,313, F. 1V)

OPPOSITE A cat and two dogs sit in the foreground of a depiction of the Last Supper. Hours of Eleonora Ippolita Gonzaga, Italy, 1530–38. (BODL., DOUCE 29, F. 56R)

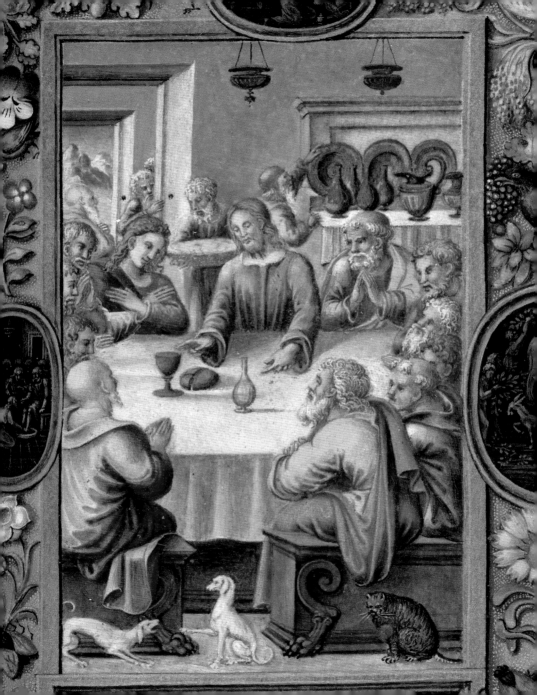

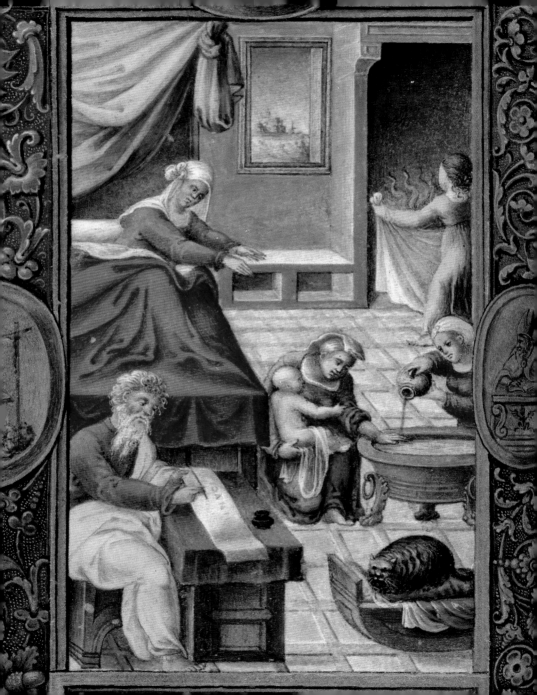

As well as infiltrating their owners' living areas,

cats even invaded bedrooms, a practice which the *Boke of Nature* deplored. It asked owners to 'dryve out dogge and catte, or els geve them a clout'. A late medieval tale tells of a knight who is rejected by a lady that he loves. He returns disguised at night and lets her cat scratch him when he enters the bedroom. On viewing

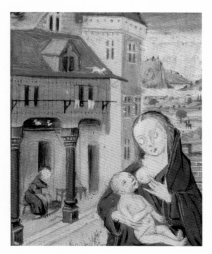

his discretion after this incident, she becomes his mistress. But the knight then refuses to marry her, claiming as his excuse that he is afraid of her cat!

In Thomas de Saluces's late fourteenth-century *Le Conte des Trois Perroquets* (*The Tale of Three Parrots*), a lady meets with her lover in her house. The next day she questions her pet parrots. The first two speak of the affair so she kills them, blaming their deaths on her pet cat (the third parrot, deciding that discretion is the better part of valour, keeps quiet!).

ABOVE A cat walks along a roof in the background of a scene of the Virgin and Child. Book of Hours, Flanders, *c.* 1480. (BODL., LITURG. 58, F. 116V)

OPPOSITE A cat sits on a cradle in a scene of the birth of St John the Baptist. Hours of Eleonora Ippolita Gonzaga, Italy, 1530–38. (BODL., DOUCE 29, F. 23V)

Domestic cats were in danger of being captured by cat skinners who sold on their fur. As provost of Paris in 1268, Étienne Boileau assessed the tax on half a dozen wild cat skins at two pence and one pence for half a dozen skins of 'private cats of the fireside or hearth'.

The thirteenth-century Franciscan chronicler Salimbene de Adam recounts how many pet cats, abandoned in towns sacked by the Holy Roman Emperor, Frederick II, in central northern Italy, were captured by an enterprising man for their fur: 'He had caught in his traps twenty-seven fine cats in the burned-out cities, and he had sold their pelts to furriers. There can be little doubt of this, because in peace time they had been pet cats in those cities.'

Urban cats did not fare well: Salimbene also recorded how in 1284 a great plague only affected cats in towns.

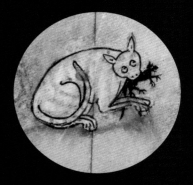

ABOVE A white cat and a mouse. Hours of the Virgin, Netherlands, 13th–14th centuries. (BL, STOWE 17, F. 129V)

OPPOSITE In an illuminated initial D, a black cat chases a mouse. Book of Hours, England, late 13th century. (BL, EGERTON 1151, F. 9V)

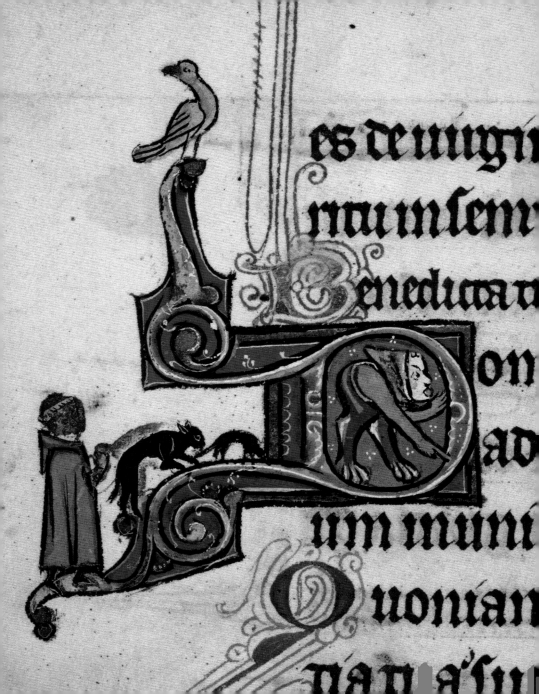

es de uirgin

rum in sem

enedicta

on

ad

um inuni

Quonian

pater su

taria tua domine uirtutum in
nerus. z deus meus.

eati qui habitant in domo

omine in secula sclox laudabu

eatus uir cuius est auxilii a

scentiones in corde suo disposu

Cats were commonly sacrificed as ritual scapegoats in popular celebrations all over Europe. In Ypres, on the second Wednesday of Lent, a city-wide feast, celebration and procession was held, which concluded with cats being thrown off a tower. In Paris, on the eve of St John the Baptist's day (24 June, the summer solstice), there was a similar city-wide celebration involving cats. Here, at the Place de la Grève – the traditional site for executions – a pyre was erected and one to two dozen cats in bags were hung from it. The king and his nobles would watch from temporary galleries, and afterwards a public feast was held, at royal expense. Cat-burning on the summer solstice was not just confined to Paris – cats were also burnt alive in Metz and Saint Chamand.

RIGHT A reddish-brown striped cat twists its head and holds a black mouse in its mouth as it climbs up the border decoration. Psalter and Hours, France, c. 1300.
(BL, YATES THOMPSON 15, F. 158V)

OPPOSITE A cat stands playing a tabor while a donkey plays a trumpet. Queen Mary Psalter, England, 1310–20.
(BL, ROYAL 2 B. VII, F. 194R)

dum appropiant sup me nocent

edant carnes meas ·

qui tribulant me inimici mei :

firmati sunt et ceciderunt ·

si consistant aduersum me cast

timebit cor meum ·

si exurgat aduersum me prel

in hoc ego sperabo ·

unam petii a domino hanc requi

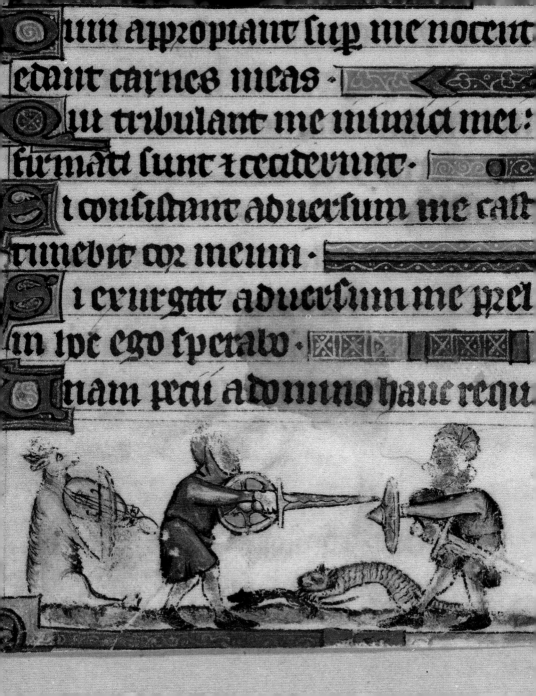

Cruelty to cats could come from many quarters. Jacques de Vitry in the early thirteenth century explains a prank played by University of Paris students. They would put a die on a cat's paw and 'let it throw'. If it threw a higher number than their number, it would be fed; if it threw lower, the unfortunate cat would be skinned and the skin sold.

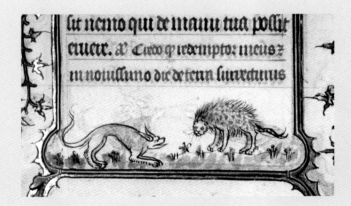

ABOVE A cat with fur raised and back arched confronts a dog. Book of Hours, France, *c.* 1400. (BODL., DOUCE 62, F. 139R)

OPPOSITE A cat chases a mouse in between two men fighting. Psalter, England, *c.* 1340. (BODL., DOUCE 131, F. 20R)

paratur : talem t sobolem procreare. etenim animalia
in coitu venerio formas externiseius insiciunt meus cor
p scariata typis : sapiut species corp in appam qualitatem
In ammantibz bigenera dicunt. qd ex diuisis nascuntur. ut
mulus ex equa t asino. burdo ex equo t asina. ybrido :
ex apris t porcis. tytyrus ex oue t hyrco. musmo ex capra
t ariete. est autc dux gregis. —

De . musione .

Musio appellatus qd
muribus infestus
sit. Hunc uulgus catu
a captura vocant. Alii
dicunt qd captat . i .
videt . nam tanto a
cute cernit : ut vir sil
gore luminis : noctis
tenebras superet . vn

De . muribz .

A greco venit catc . i . ingeniosus. —

Mus pusillu animal grecu nomen est.
quicqd vero ex eo thic : latinu est. Alii
dicunt mures. qd ex humore tre nascant.
nam humus tra. t mus
t his in plenilunio iecur
crescat sicut quedam maritima augent.
quo rursus minuente luna deficiunt. —

De mustela

Records of famine or sieges usually speak of urban

populations eating dogs and cats in order to emphasize the severity of the food shortage, as neither was part of the usual diet.

There is a medieval siege weapon called 'the cat', which consists of a tall wooden structure, with a moving apparatus to claw at the wall.

Medieval cats have been found in archaeological excavations. An excavation in Verona found a large quantity of cat bones, mainly thirteenth-century, which suggested that cat corpses were generally thrown away onto a few waste pits. The cats could have had various functions, from being pets to being skinned for their pelts, although no butchery or flesh-stripping marks were found on the remains.

Cats have also been found buried alive in medieval buildings. Various explanations have been suggested, from accidental entry to foundation sacrifices or to ward off mice. The cat and mouse found in a small wall cavity at Hay Hall, Birmingham, must have been placed there on purpose: the building was constructed in the thirteenth century and as the cavity was sealed they could not possibly have gained entry subsequently by accident.

ABOVE A green striped cat and mouse decorate an initial I. Justinian, *Codex Justiniani*, England, *c.* 1250. (BL, HARLEY 3753, F. 28V)

OPPOSITE One cat is depicted cleaning itself, another holding a mouse, in a bestiary text on cats. England, 1300. (BODL., DOUCE 151, F. 29V)

In England, according to the Sumptuary Law of 1363, cat, lamb, rabbit and fox were the only types of fur allowed for esquires and gentlemen under the rank of knight with land worth up to £100 a year, craftsmen and artisans with goods up to £500 a year, and all yeomen, grooms and servants. Cat fur was seen as low quality and was usually sold by pedlars. Thus in Langland's *Piers Plowman* (*c.* 1377), Covetousness says:

> I have as much pity of poor men as a pedlar hath of cattes
> Who would kill them [the cats], if he could catch them,
> for he covets their skins.

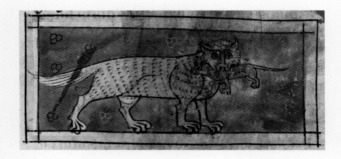

ABOVE A large striped cat is illustrated with a mouse in its mouth. Bestiary, England, mid- to late 13th century.
(BL, SLOANE 3544, F. 20V)

OPPOSITE A cat can be seen (bottom right) in this opening page of the Gospel of Mark. Lindisfarne Gospels, Northumbria, late 7th or early 8th century.
(BL, COTTON NERO D IV, F. 139R)

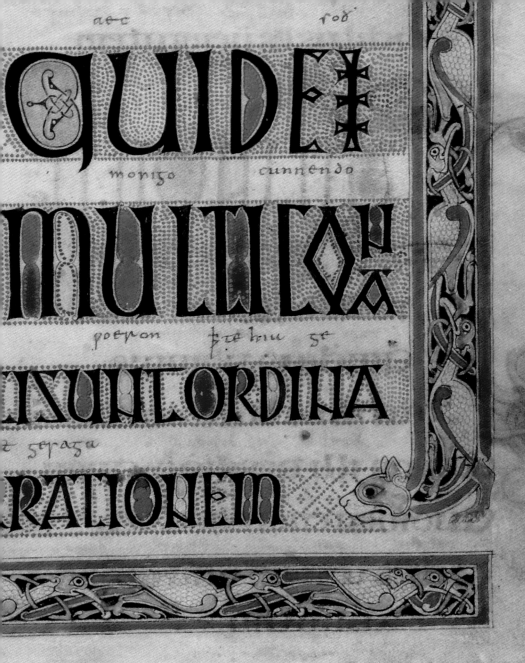

QUIDE+ ✝

MULTI

SUNTORDINA

RATIONEM

les .xv. ioies

Ouce dame de
miſericorde me
re de pitie fontay
ne de tous bies

Cats were often associated with the monastic order, perhaps due to their contemplative and quiet nature. An Old Irish poem extolling his pet cat, Pangur Bán, was written by an unknown Irish monk in Carinthia in the margin of his copy of St Paul's Epistles in the eighth/ninth century:

I and Pangur Bán, my cat
'Tis a like task we are at;
Hunting mice is his delight
Hunting words I sit all night...
Oftentimes a mouse will stray
In the hero Pangur's way:
Oftentimes my keen thought set
Takes a meaning in its net.
'Gainst the wall he sets his eye
Full and fierce and sharp and sly;
'Gainst the wall of knowledge I
All my little wisdom try.
When a mouse darts from its den,
O how glad is Pangur then!
O what gladness do I prove
When I solve the doubts I love!...

ABOVE Within an initial R, a cat preaches at a lectern as one mouse listens and two play. Psalter, St Augustine's Abbey, Canterbury, c. 1210–20.
(BODL., ASHMOLE 1525, F. 40R)

OPPOSITE A small cat stands in the foreground on grass in front of the Virgin and Child. Book of Hours, Flanders, 1430–40.
(BODL., CANON LITURG. 92, F. 103R)

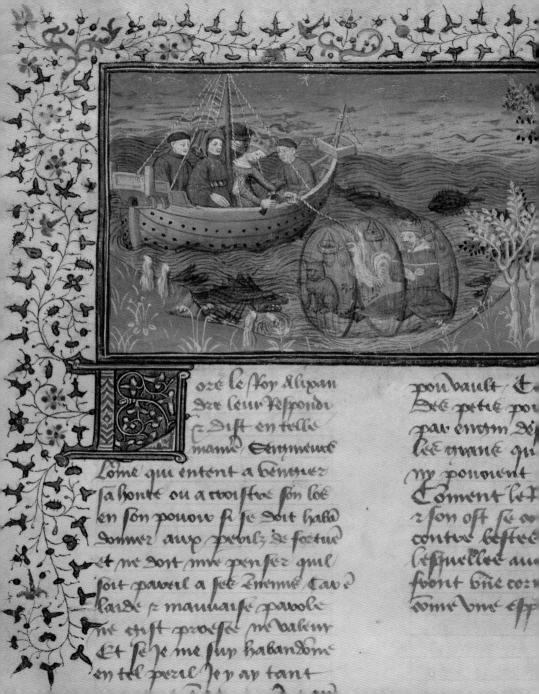

ozt le Roy Alixan
dre leur Respondi
z Dist en telle
maniere Seygneurs
L'ome qui entent a venchier
sa honte ou a croistre son loz
en son pouoir si se doit haster
donner aux perilz de fortune
et ne doit mie penser quil
soit pareil a ses enemis tant
lades z maunaise parole
ne cust prousse ne valeur
Et se ie me suy habandonne
en tel peril iey ay tant

pou vault t
lee petie pou
par enan Asp
lee grant qu
ny pouuent
Comment le
z son ost se
contre bestee
lesquelles au
front une co
tome une esp

The *Vita Sancti Brendani* (*The Life of St Brendan*) recounts how the Irish St Brendan encountered on his voyages an aggressive giant sea-cat, whose origin as a small pet cat is explained by the surviving monk on the island: 'We came in a boat with our very friendly cat who grew very large from eating fish, but Jesus Christ, our Lord, has never allowed it to harm us.'

The tale is expanded in the Book of Leinster, a collection of tales in Old Irish, which explains how three students went on a pilgrimage with three loaves of bread and their cat. They arrived at an island where the cat brought them three salmon every day. They decided not to eat the cat's food and luckily after six days they were sent food from heaven. But the cat continued to eat so much of the local fish that it was transformed into the giant sea-cat that attacked St Brendan's party.

A popular addition to the legend of Alexander the Great involved him going under the sea in a bathysphere, accompanied by a cockerel and a cat. *The History of the Deeds of Alexander the Great*, France, early 15th century. (BL, ROYAL 20 B XX, F. 77V)

Cats were commonly kept as pets by nuns, although this practice did not always meet with approval. A set of rules in the nunnery of Langendorf, Saxony, in the early fifteenth century insisted that 'cats, dogs and other animals are not to be kept by nuns as they distract from seriousness'.

In the *Ancrene Riwle*, an early thirteenth-century guide for anchoresses, a ruling allowed cats while prohibiting other types of pets: 'Unless need compels you, my dear sisters, and your director advises it, you must not keep any animal except a cat....

Now if someone needs to keep one, let her see to it that it does not annoy anyone or do any harm to anybody, and that her thoughts are not taken up with it. An anchoress ought not to have anything which draws her heart outward.'

The twelfth-century nun Hildegard of Bingen, in her *Liber simplicis medicinae* (*Book of Simple Medicines*), mentions the disloyalty of cats, who only bother to stay with whoever feeds them.

ABOVE A cat and a dog coming out of the foliate decoration snarl at each other. Gospel lectionary of Gregory XIII, Italy, 1578. (BL, ADD. 35,254, F. K)

OPPOSITE A nun with a distaff plays with a white cat who is leaping about with the spool. Hours of the Virgin, Netherlands, 13th–14th centuries. (BL, STOWE 17, F. 34R)

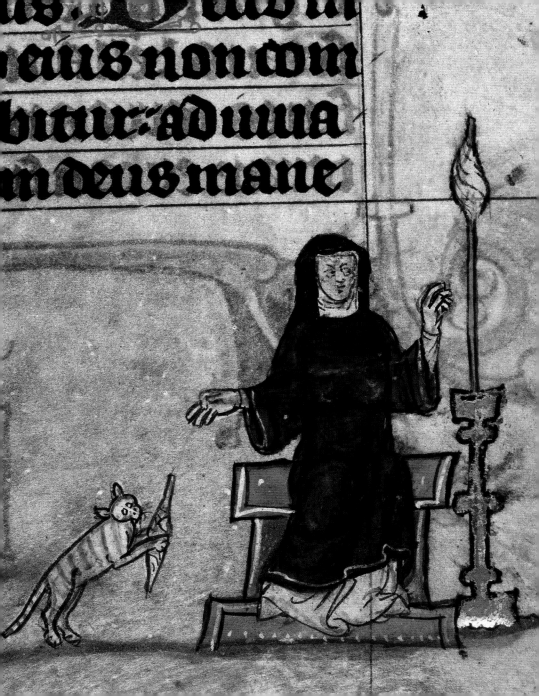

eus non com
bitur:aduuia
m deus mane

The presence of a cat could be justified on practical grounds: it could be kept under the official guise of a destroyer of vermin and thus become a pet 'through the back door'. This was literally the case for the 'official' cats of Exeter Cathedral, where there are entries in the accounts from 1305 to 1467 *custoribus et cato* (for the keepers and the cat) and *pro cato* (for the cat), amounting to a penny a week (to supplement the animal's diet, in addition to the pests it was supposed to control). There is still a cat-hole in the door of the north transept wall today.

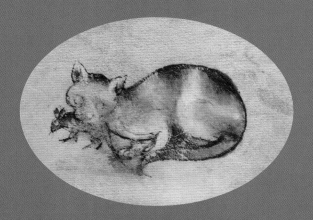

ABOVE A large white and grey cat sits eating a small mouse. Book of Hours, England, late 13th century. (BL, HARLEY 928, F. 44V)

OPPOSITE In an initial Q, a dog bites a cat who in turn bites a mouse (while swatting another mouse at its feet). *Moralia in Job* by Gregory the Great, Germany, late 12th century. (BL, HARLEY 3053, F. 56V)

cucꝫ hunc hypocrita ut impiu dicerent. p̄ hoc
quod ipsi mentientes ꝓpetrabant culpam. augebāt
p̄culdubio penā rusti. uulnerib; afflicti. Nam sēoꝝ
mentes q̄ ueritatē diligt̄: ꝯ culpa fallatie tor
quet aliene: Quanto enī mdaciꝯ que ēē ēmen
aspiciunt. tanto hoc n̄ solū mfe: s; ꝯ �22 aliis odeꝛt
finit liber x. xv? Incipit. xvi? ---

ut contra uerita
tis uerba in alle
gatione deficiut̄.
sepe etiam nota
replicant. ne ta
cendo uicti uide
ant̄. vnde eli
phaz beati iob
sermonib; pressus

Whilst the cat became a very familiar pet among those in religious orders, keeping monastic pets did not always go smoothly. On rare occasions cats may have posed a danger, as for example when a prioress at Newington was apparently smothered by her cat in her bed while she slept. In John Skelton's early sixteenth-century elegy, 'The Book of Philip Sparrow', there is great mourning for Philip Sparrow, a pet of Jane Scrope at the convent of Carrow (near Norwich):

> I wept and I wayled,
> The tearys downe hayled;
> But nothinge it avayled
> To call Phylyp agayne,
> Whom Gyb our cat hath slayne.

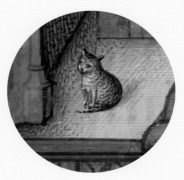

OPPOSITE AND DETAIL ABOVE There are no references to cats in the Bible, however in this miniature showing the evangelist Mark writing the gospel, he is accompanied not only by his symbolic lion, but also a grey cat. Flemish artists, late 15th century. (BL, ADD. MS 35,313, F. 16R)

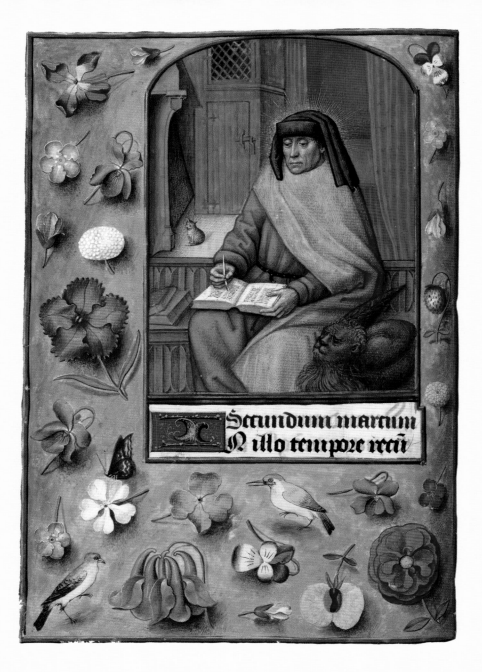

Secundum marcum
Jn illo tempore recu

For Salimbene de Adam, the thirteenth-century Franciscan chronicler, there was a difference between St Francis's love of wild animals and the keeping of pets, including cats, which he saw as a frivolous pursuit that caused the pet-owner to lose the respect of his fellow friars: 'I have seen in my own order, which is the order of the blessed Francis and the Friars Minor, some lectors who despite being highly learned and of great sanctity, nevertheless had a blemish on account of which they are judged by others to be frivolous men. For they like to play with cats, little dogs and little birds, but not as the blessed Francis played with a pheasant and a cicada while delighting in the Lord.'

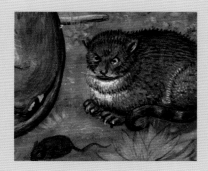

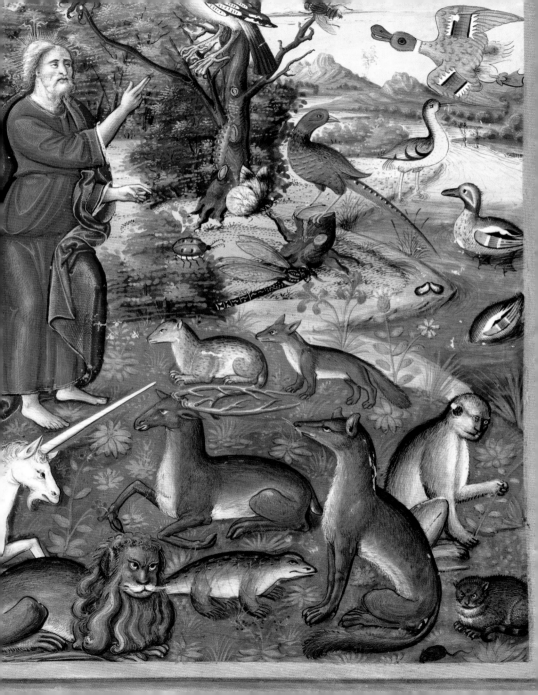

ex oue ⁊ yrcho. mulino ex cap ⁊ar

M̄vs
q̄d captat.
luminis ne
t. i. ingeni
us pull
latini
nascantur. Ham humus terra ⁊ m̄.
q̄dā maritima augent. q̄ rurs̄ mu
Mustē
gu d
u ha
locū tr̄lsfert. mutataq; sede locat.

Bartholomeus Anglicus's thirteenth-century

compendium *De proprietatibus rerum* (*On the Properties of Things*) gives false etymologies for the Latin terms for cat of *mureligus*, *musio* and *catus*, which originally appeared in the work of Isidore of Seville. He explains that the etymology of the first two names comes from the cat being an enemy of mice (*mus* in Latin). The third term, *catus*, he claimed came from the Latin verb 'captare' (to capture). He explains that cats come in different colours – white, ginger and black – and some are spotted like leopards. They have a great mouth, sharp teeth and a long soft tongue. When they are young, he says, they are very lecherous and jump on everything put before them, but when elderly they are heavy and always sleepy.

ABOVE Three cats are depicted, one hanging upside down, together with a mouse on an egg and a rat. *The Tudor Pattern Book*, England, *c.* 1520–30.
(BODL., ASHMOLE 1504, F. 32V)

OPPOSITE A large striped cat ('*musio*') looks at a mouse ('*mus*') below him, who is followed by a weasel ('*mustela*') in a bestiary describing each animal. England, *c.* 1170. (BL, ADD. 11,283 F. 15R)

There are copious collections of cat lore in works on natural history and encylopaedias. The thirteenth-century encyclopaedist Thomas de Cantimpré in his work *De natura rerum* (*On the Nature of Things*) describes why cats purr: 'They delight in being stroked by the hand of a person and they express their joy with their own form of singing.'

In bestiaries, compendia of animal lore compiled from sources as diverse as Ambrose, the Physiologus, Solinus and Isidore of Seville, the cat is famed for its ability as a mouser, and for its keen and piercing eyesight, which could overcome the darkness of night.

Illustrations from the Middle Dutch translation of Thomas de Cantimpré's *De natura rerum*: a large grey-white cat (opposite) eats a mouse while standing on a clump of green grass next to the label 'cat'; two cats attack snakes that look like dragons (above). Flanders, 13th century. (BL, ADD. 11,390, F. 21)

en mamonet
an trachte bet
et scalreden
e meneghe geel
en moet
e hare doet
et
leghet
onc
e sprone
in nacht
cracht
e mede
ehede
bedruuenhede
etter vrede
laet
te so quaet
inen cant
it

mule parde
hauer leet
en alle ene
mene woet
vacht

D ie si hem hebben ghedaen
M oeten si int heynde tcollene gaen
H oet vechten si hour ghewaghen
M et padden die venyn draghe
M aer drinken si niet te hant dar naer
S i sterven van durste daer
D en serpenten doen si pine
O ughelcader van haren venine

⸿ alle die catten
willen riden.
werden si vrl
en willen ti
vre dane on
hare ghenoe

H are vechten anderlanghe es groet
D att bedi dat wanemen wale
D at elc wil ouden sinen pale
D aer hi inmuten sal
A lse mense striket verheft soe hare al
W arme steden mint soe so wel
D att hem dicken ouernet dat vel
C orte men hare gherne an hare bart
S o werden si blode ende veruart
D en gonen die te vre ontgaen
M en corte hem die hoven saen

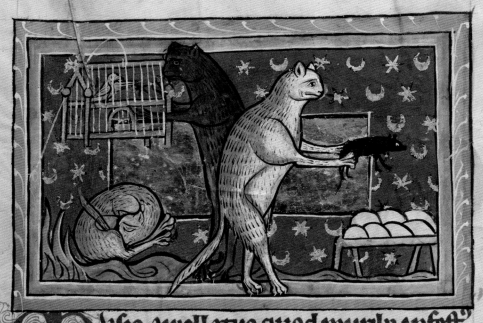

Musto appellatus quod muribz infest[us]
sit. Hunc uulgus catum a captura
uocant. Alii dicunt quod captat id e[st]
uidet. Nam tam acute cernit ut fulgore lumi
nis noctis tenebras super[et]. Unde a greco uenit
catus id est ingeniosus. απο του καιεσθαι.

[U]s pusillum
animal grecu[m]
illi nomen est
quicquid u[ero] ex eo t[ra]h[itur]
latinum sit. Alii dicunt

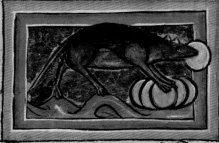

mures quod ex humore terre nascantur. Nam

Albertus Magnus, in his thirteenth-century work *De animalibus* (*On Animals*), speaks of how the cat 'takes delight in cleanliness and for this reason imitates the washing of a face by licking its front paws and then, by licking it, smooths all of its fur.... This animal loves to be lightly stroked by human hands and is playful, especially when it is young. When it sees its own image in a mirror it plays with that and if, perchance, it should see itself from above in the water of a well, it wants to play, falls in, and drowns since it is harmed by being made very wet and dies unless it is dried out quickly. It especially likes warm places and can be kept home more easily if its ears are clipped since it cannot tolerate the night dew dripping into its ears. It is both wild and domesticated. The wild ones are all grey in colour, but the domestic ones have various colours. They have whiskers around their mouth and if these are cut off they lose their boldness.'

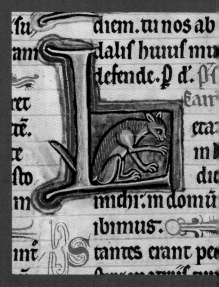

ABOVE A cat sits in the initial L. Psalter, St Augustine's Abbey, Canterbury, *c.* 1210–20.
(BODL., ASHMOLE 1525, F. 109R)

OPPOSITE Three cats engaged in feline activities illustrate a bestiary text on cats. One is curled up sleeping, one is reaching into a birdcage and the third is lifting a mouse off a nest of eggs. England, mid-13th century.
(BODL., BODLEY 764, F. 51R)

Albertus Magnus wrote on the supposed medicinal qualities of cats. He claimed that the flesh of a wild cat could be placed on limbs suffering from gout; that the bile of a wild cat, if ingested, was good for facial pains or tics; and that half an ounce of the bile of a black cat (when mixed with Arabian jasmine) produced a sneezing powder. Other popular cat remedies included the rubbing in one's eye of a tom cat's tail to cure a stye.

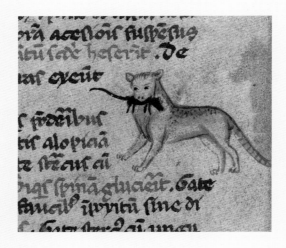

ABOVE A cat holding a mouse in its mouth accompanies a text on the medical and magical properties of cats. *Medicinal Secrets of Galen*, Italy, mid-14th century. (BODL., RAWLINSON C. 328, F. 123V)

OPPPOSITE A bestiary text on cats is illustrated with a reddish-brown cat cleaning itself, a grey cat holding a mouse and a white cat chasing another mouse. Mice and weasels are described below. England, early 13th century. (BODL., ASHMOLE 1511, F. 35V)

eterno uoluptati eiul dum concipiunt talem ꝓ ſobolem
parent: ꝶenum animalia muſtu ueneꝛio formaſ extrinſecꝰ
tſtmittunt uꝶ. eorumꝗ; ſaciata typiſ. rapit ſpecief eoꝛum
iꝫ ꝑam qualitatem; Jn animantibꝰ bigeꝛia dicuntꝰ q̄ exdiu
ſiſ naſcuntǔ. ut muluſ. ex eq̄ ꞇ aſino. burdo ex equo ꞇ aſina.
ybride ex apꝛiſ ꞇ poꝛciſ. tyꝛi ex oue ꞇ yꝛco. muſino ex capra ꞇ arie
te. eſt autem dux gregiſ;

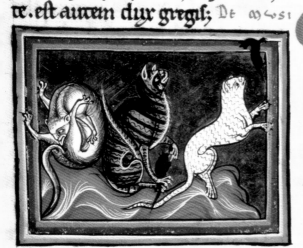

Muſio apellatuꝛ
q̄d muribꝰ infeſt ſit.
hunc uulguſ catum
a captura uocant. Alii
dicunt quod captat
·i· uidet; Ꝛ̌am tanto
acute cernit: ut ful
goꝛe luminiſ noctiſ
tenebraſ ſupet; Ꝩn
de a gꝛeco uenit catuſ ideſt ingenioſuſ;

Muſ puſillum animal gꝛecum no
men .ē. quiꝉqd ꝫ ex eo tꝛahit. lati
num ſit; Alii dicunt mureſ q̄d ex umoꝛe
tꝛe naſcantǔ; Ꝛ̌am humuſ ꞇꝛa ꞇ muſ ·i· hꝰ
impleniluuio iecur creſcit.
ſicut quedam maritima augentur. que rur
ſuſ minuente luna deficiunt;

mittut. qn̄o canes insequentes patitur
ꝓbitatem subsequentiu̅ repellit ·

uelegus appl̅latꝰ
sit infestus. huic
captura uotauit
ndet̄z̄iam adeo ·

noctis tenebras uisu super. u̅i agreto ue
tenosius. apostoꝛ ercla hic tu̅ stomacu̅ tibo
· festicas carpit ar g̅itatuerta uomit̅ ꝓuoc·
a̅ial grectu̅ ist nomen
d si ex eo trahit latini
ntrei. qd ex humore
r̄z̄iam mus terra· u̅i
plenibmio reuit trestib siut q̅ d̅ mari
que rursum minuente luna deficiut
zeo qd rodit. Jm modu̅ telte ꝓsidit anni
sancit̅ dicebant. haroꝰ clodiui̅ claudiui·

Cats appear in numerous fables. One of the most famous, retold in many works such as the late thirteenth-century *Gesta Romanorum* (*Deeds of the Romans*) tells of how the fox brags to the cat about how he has a whole bag of tricks, while the cat confesses that he knows only one, which is to run up a tree when chased by dogs. As the fox and the cat are walking along together, hunters and hounds approach. The fox tells the cat not to be afraid but the cat decides to use his trick and scampers up the tree. As the dogs pounce on the fox, the cat in the tree cries out to him:

'Open your bag of tricks and help yourself, as none of your tricks are helping you!'

Another fable from the same work tells of a mouse that fell into a barrel of ale and cried out for help. A cat arrived and made the mouse swear that if he rescued him, the mouse must respond whenever the cat called. The mouse agreed so the cat helped him out and let him go. Later on, the cat was hungry so went to the mouse's hole and called for him, but the mouse refused to come out, claiming that he was afraid of the cat. The cat demanded that the mouse hold his oath. The mouse replied 'Brother, I was drunk when I swore, and therefore I do not have to keep my oath'.

ABOVE A small reddish-brown cat stares at a mouse running away. Psalter and Hours, France, *c*. 1300. (BL, YATES THOMPSON 15, F. 188V)

OPPOSITE A grey cat eats a mouse surrounded by more mice, a dog and a mole. Bestiary, England, *c*. 1300. (BODL., DOUCE 88, F. 95R)

S iqme thibett le chat est en vne
hudse et hmne plem pot de leu
E por. le souttient le couuercle
tela hudse

S fu en mai autepr nouel
E li temps est serr z bel
S come estoit la setton
Q . R . fu en samaiton

In the tales of *Reynard the Fox*,

Tibert the Cat is one of his companions but is often cruelly tricked by him. In one story Reynard tells Tibert that he will find many mice to eat in a barn belonging to a priest. Tibert declares that he loves mice better than anything man could give him, including venison and pastries, and begs to be led there. However, when Tibert enters the barn he is immediately caught in a trap laid by the priest. It transpires that Reynard knew all about the trap: it was in fact set for him as he had stolen a hen from the barn the night before. Tibert cries and mews as he is in a great deal of pain. The priest races out to catch the thief and begins to beat Tibert, but the cat manages to escape.

Reynard the Fox and Tibert the Cat sit at the foot of a tree. *Roman de Renard* (*Romance of Reynard the Fox*), France, 1339. (BODL., DOUCE 360, F. 99R)

'Cuirm lemm, lemlacht la cat' ['Beer with me, fresh milk with a cat']
Medieval Irish proverb

Cats sometimes appear in proverbs. John Gower, for example, uses a popular proverb in his fourteenth-century *Confessio Amantis* (*The Lover's Confession*), involving a cat who wants fish but does not want to get its paws wet: 'as a cat would eat fishes without wetting its paws'. This is the proverb to which Lady Macbeth is referring when she says 'Like the poor cat i' the adage' (*Macbeth*, Act 2,

Scene 7), wanting something but not willing to do what is necessary to get it.

A proverb attributed to John Wyclif in 1383 speaks of how 'Many man of law ... bi here suteltes [by their subtleties] turned the cat in the panne [made things appear the opposite to what they are]'. In a description of a giant herdsman in the early fourteenth-century romance *Ywain and Gawain*, his flat nose is described as 'cutted als a cat'.

ABOVE Border decoration showing a cat seated at a table laid with fish in blue dishes, attended by large mice servants. Missal, England, mid-15th century. (BODL., LAUD MISC. 302, F. 210R)

OPPOSITE A white cat eats a mouse below an initial R. Hours of the Virgin, Netherlands, 13th–14th centuries. (BL, STOWE 17, F. 75V)

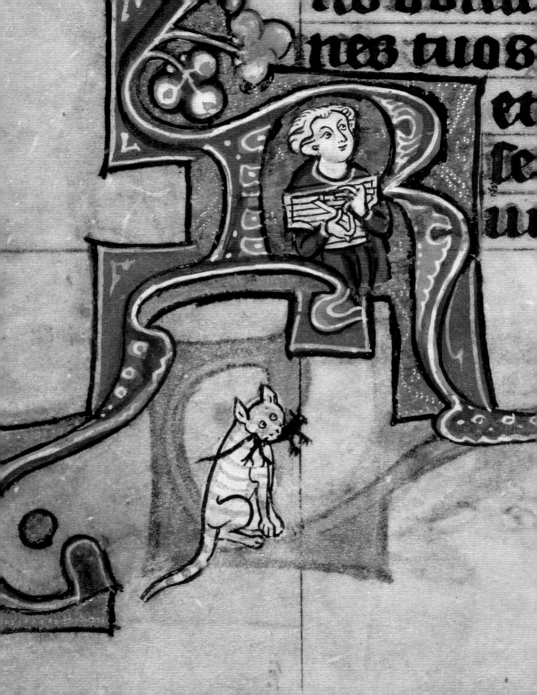

nes tuos

A famous rhyme on Richard III speaks of:

> The Cat, the Rat and Lovell our dog
> Rule all England under the Hog.

This is an allusion to three trusty councillors who were all involved in royal administration under Richard III. The 'Cat' is a reference to William Catesby, Speaker of the House of Commons, the 'Rat' Sir Richard Ratcliffe, Knight of the Garter, and 'Lovell our Dog' Viscount Lovell, Knight of the Garter, whose heraldic symbol was a talbot dog. The 'Hog' is Richard III himself (the boar being his heraldic symbol).

Cats, both wild and domestic, appear in heraldry; its usual heraldic term was 'musion' (rat-catcher). A legend claimed that a French knight was granted the arms of an imprisoned cat by Childebert, the sixth-century king of the Franks, when he captured Gundemar of Burgundy, whose emblem was a cat.

omnie labia me
a apnes.
tos meum
annuaabit laudem tuam.

In Chaucer's *Canterbury Tales*, the Wife of Bath

explains what one of her former husbands used to say to her:

> Thou said this, that I was like a cat,
> For whoever would singe a cat's skin
> That would make the cat always stay inside,
> And if the cat's skin were sleek and gay
> She would not dwell in the house for half a day,
> But out she will go, before the dawn of day
> To show her skin, and go a-caterwaulling.

The reference to singeing a cat's fur comes from a belief that it would make the animal keep to the house. The thirteenth-century Odo of Cheriton explained that 'if a cat will not stay home, shorten her tail and singe her fur. The same applies with wives' (a reference to the shaming of vain women wearing gowns with long trains in public). Jacques de Vitry has a similar example, in which a beautiful cat likes wandering about until its master burns its tail and pulls out its hairs, making the cat too ashamed to leave the house.

While the Wife of Bath is accused by her husband of being a cat, she in turn compares him to a mouse, 'as dronken as a mouse', emphasizing her predatory nature. To add to the symbolism, the female cat was, according to Aristotle, believed to be a very lustful beast.

A cat with a mouse in its mouth (top) runs among various characters, including a knight with sword and shield fighting a devil-grotesque, and a woman in a green robe. Psalter, Flanders, *c.* 1320–30. (BODL., DOUCE 5, F. 44R)

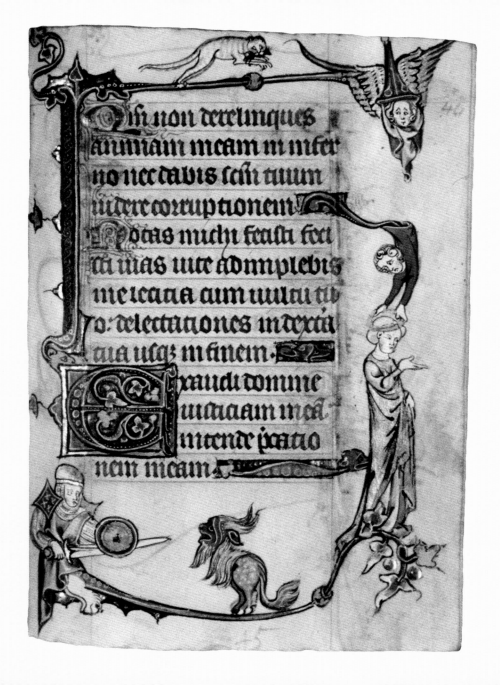

isi non derelinques
animam meam in inser
no nec dabis seru tuum
uidere corruptionem
otas michi fecisti uiti
cii uias uite adimplebis
me leticia cum uultu tu
o: delectationes in deria
tua usq: in finem.

xaudi domine
iusticiam meam
intende deracio
nem meam.

In Chaucer's *Miller's Tale* a servant peeks through a cat-hole in a door, like the one in Exeter Cathedral:

> A hole he found, low down upon a board
> Through which the cat was wont to creep.

In the same tale Absolon's desire for Alison is described in proverbial cat–mouse terms:

> I dare well say, if she had been a mouse,
> And he a cat, he would soon have seized her.

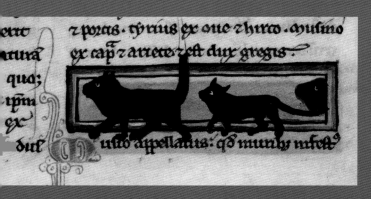

ABOVE A large black cat is followed by a kitten, while the head of another cat edges out of the frame. Bestiary, England, mid-13th century. (BODL., BODLEY 533, F. 13R)

OPPOSITE Below a scene showing the gift of a ring, a large cat watches a mouse hole. The Ormesby Psalter, England, late 13th/early 14th century. (BODL., DOUCE 366, F. 131R)

amqꝫ die inuocauero te: uelo
udi me.

erunt sicut fumus dies mei:
ea sicut cremium aruerunt.
sum ut fenu ⁊ aruit cor meu:
us sum comedere panem meu.
nitus mei: adhesit os meum

Chaucer in his *Manciple's Tale* compares a lustful wife
that cannot be tamed by being locked up to a domestic cat: even
if spoiled with milk and meat, and given a couch of silk,
it will still leave all these luxuries behind to chase a mouse:

Let's take a cat, and feed him well with milk
And tender flesh, and make his couch of silk,
And let him see a mouse go by the wall,
Then he waives milk and flesh and all,
And every dainty that is in that house,
Such an appetite he has to eat a mouse.
Lo, here desire dominates
And appetite drives out discretion.

OPPOSITE AND DETAIL ABOVE A reddish-brown cat eats a black
mouse above a decorated initial D (the Annunciation to the shepherds).
Psalter and Hours, France, *c.* 1300. (BL, YATES THOMPSON 15, F. 314V)

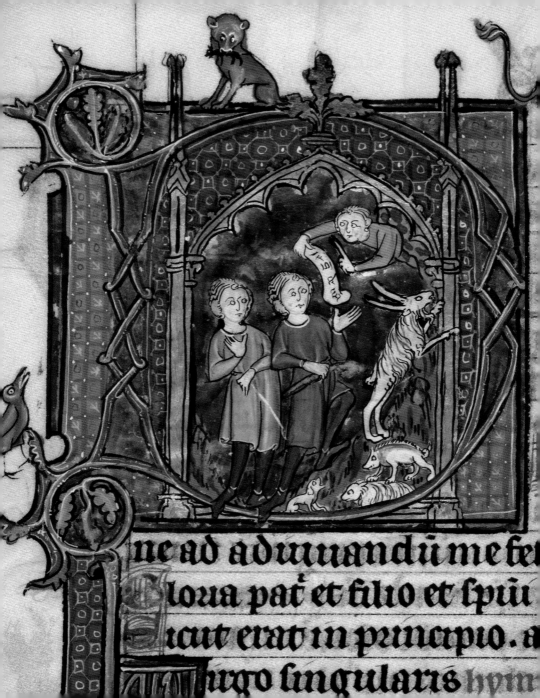

ne ad adiuuandū me fe
loria pꝛ et filio et ſpū
cut erat in pꝛincipio. a
rgo ſingularis hym

In the correspondence dated from 1395 to 1402, between Margherita di Domenico Bandini in Florence to her husband Francesco di Marco Datini in Prato, there are numerous references to their cats. These include the struggles to find a suitable male for their female cat to breed kittens (Margherita could not locate one in Florence and dispatched the cat to Francesco in Prato, sending cats by coach between the two cities), being given cats as pets and the perils of cats trying to escape from the house, with numerous attempts to tie them up.

A carefully drawn cat follows a mouse. Herbal, Italy, c. 1440. (BL, SLOANE 4016, F. 40)

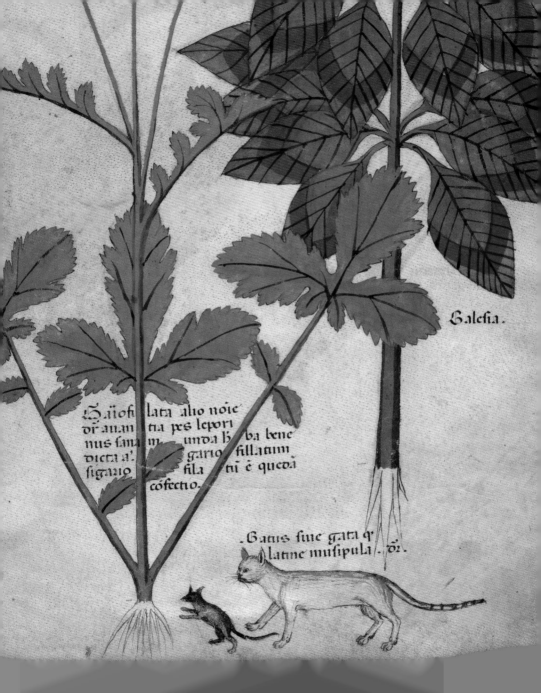

Galesia.

Sñofi lata alio noie
di anam ta pes lepori
nus sana m unda h ba bene
dicta a' garios fillatim
sigario fila ti e queda
cofectio.

Gatus siue gata q'
latine musipula di.

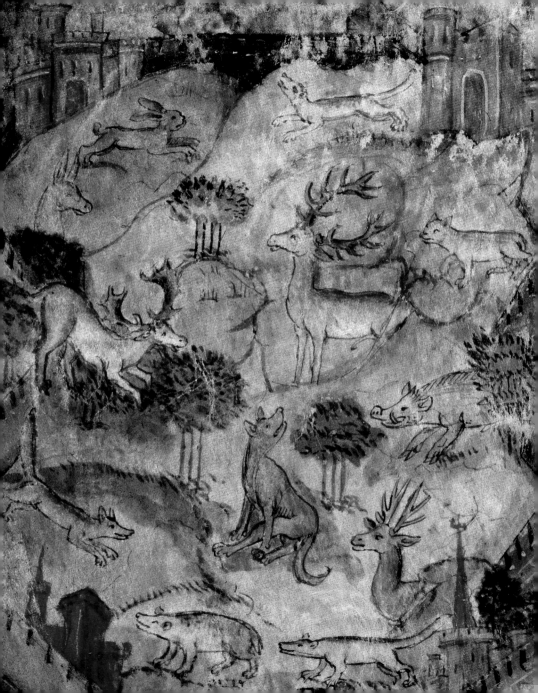

Wild cats roamed the countryside of medieval
Europe. In *The Master of Game*, translated in the early fifteenth
century by Edward, Duke of York, from Gaston Phebus's *L'Arte de
la Chasse*, the wild cat is described thus: 'There be some cats as big
as leopards.... They live on such meat as other cats do, save that
they take hens in hedges and goats and sheep, if they find them
alone, for they be as big as a wolf, and almost formed and made as
a leopard, but their tail is not so long.... Men hunt them but
seldom, but if the hounds find peradventure such a cat, he would
not long be hunted for soon he putteth him to his defence or
he runneth up a tree.... They bear their kittens and in their
love as other cats, save that they have but two kittens at once....
Of common wild cats I need not to speak much, for every hunter
in England knoweth them, and their falseness and malice are
well known.'

ABOVE Ink drawing of a fierce wild cat stretched out with claws extended, mouth open and
whiskers flashing, fighting a dragon. Queen Mary Psalter, England, 1310–20.
(BL, ROYAL 2 B. VII, F. 188R)

OPPOSITE A full-page miniature of animals of the chase in an enclosed garden, including
a wild cat in the top right-hand corner among foxes, stags and boars. *The Master of the Game*
by Edward, Duke of York, England, mid-15th century. (BODL., BODLEY 546, F. 3V)

The cat was often associated with heresy.

In his work *De fide catholica contra haereticos* (*Against Heretics*), the twelfth-century French theologian, Alain de Lille, when discussing the heretical Cathars, claimed that the word 'Cathar' came from cats. He explained that the Cathars worshipped a large black cat, in reality the Devil in disguise, and kissed its bottom during their religious services.

His contemporary, Walter Map, from the Welsh Marches, repeated the same calumny against the *Publicani* in England, another heretical sect. He described in detail how they waited in the darkness until a black cat 'of wondrous size' descended down a rope, and then they would kiss the cat all over, particularly around its tail. The Waldensians were also accused of similar acts and one of the charges against the Knights Templar at their trial in 1309 was the accusation that they worshipped a devilish cat.

ABOVE An initial P for Psalm 118 decorated with a blue cat. Psalter, England, 1200. (BODL., GOUGH LITURG. 2, F. 126V)

OPPOSITE A grey cat crouches with a brown mouse in its mouth above an initial B of King David tuning his harp. The Luttrell Psalter, England, *c.* 1325–35. (BL, ADD. 42,130, F. 13R)

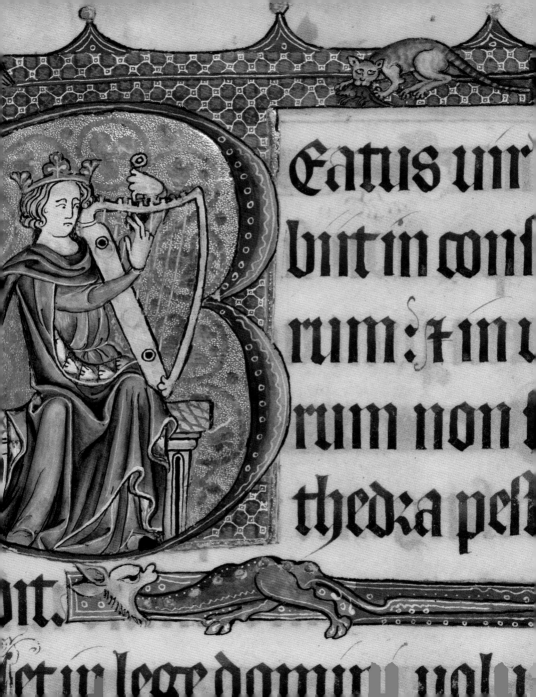

Eatus uir

bit in conf

rum: t in u

rum non t

thedra pest

oit.

et in lege domini uolu

The cat's association with magic, heresy and witchcraft was partly due to its peculiar status as an animal that was both domesticated and wild. In Kilkenny, Ireland, Alice Kyteler was accused during her trial in 1324 for heresy of keeping a devilish incubus that appeared in the shape of a black and very furry cat, as well as poisoning her four husbands. Alice fled to England, but her servant Petronella was not so lucky: accused of being Alice's accomplice, she was burnt at the stake.

The first cat mentioned at an English witch trial was a white spotted one appropriately named Satan, who belonged to one Elizabeth Francis in 1556. The cat had been a gift from her grandmother when Elizabeth had agreed to renounce God. Satan the cat regularly spoke to her 'in a straunge holowe voice' and had great powers. However, in return for every deed that Satan the cat did for Elizabeth, she had to give him a pinprick of her blood.

A winged cat flies as a man shoots at it with his bow (opposite); and a man with a bow and arrow shoots at a white cat climbing a tree (above). Hours of the Virgin, 13th–14th centuries. (BL, STOWE 17, FF. 174R, 258V AND 259R)

tephane · · · · · · · · · · oz
line · · · · · · · · · · · · oz
clete · · · · · · · · · · · oz
clemens · · · · · · · · oz
lyte · · · · · · · · · · · · oz
donate · · · · · · · · · oz
ypolite · · · · · · · · · oz
laurenti · · · · · · · · oz
vincenti · · · · · · · · oz
georgi · · · · · · · · · · oz
dyonisi cū cociis

...illumatione et nat...nen...

ı̄ın meditacione mea exar

deseet ignis.

Loquutus sum in lingua

mea : notum fac michi domine

finem meum.

Et numerum dierum meoꝛ

quis e̅ ı̅r scıam quıd desttea...

Tales of shape-changing women who could turn into cats and vice versa were common in medieval literature. Gervase of Tilbury, in his thirteenth-century *Otia imperialia* (*Recreation for an Emperor*) spoke of women who were wounded while in the shape of cats, and then had the same wounds when in human form. *The Maleus Maleficarum* (*The Hammer of Witches*), a famous treatise on witches written in 1486, spoke of a similar story in which a man was out in the forest chopping wood. He was attacked by three cats while working, and only just managed to fend them off by hitting them. He was later arrested on a charge of beating three respectable women of the town. In the end he managed to convince the magistrate of the truth of his tale.

ABOVE A cat's head with foliage coming out of its ears decorates the top border of an Italian Book of Hours. Sforza Hours, Italy, *c.* 1490. (BL, ADD. 34294, F. 48)

OPPOSITE A cat and a centaur confront each other, each raising one front leg. The Oscott Psalter, England, *c.* 1265–70. (BL, ADD. 50,000, F. 66V)

Cats were often compared to the Devil or to death.
The mid-fourteenth century work *Ayenbite of Inwyt* (*The Prick of Conscience*) repeated the popular proverb of how the Devil plays with the sinner like a cat does a mouse. Odo of Cheriton in the early thirteenth century explored the idea of the Devil-Cat, explaining how the cat who eats mice is like the Devil who tempts those who disobey the Church's teaching, and then devours them and throws them into hell. Edward, Duke of York, declared in his book on hunting that 'if any beast hath the devil's spirit, it is the cat'.

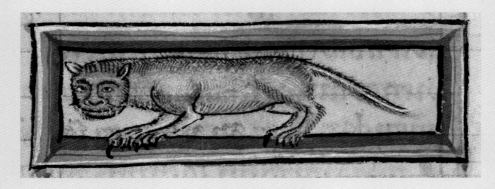

ABOVE A grey cat with a strange head from *De medicina ex animalibus* (*On Medicines Made from Animals*) by Sextus Placitus. England, late 12th century. (BL, SLOANE 1975, F. 86V)

OPPOSITE A lion and a cat sit at the foot of St Catherine's tomb on Mount Sinai. Queen Mary Psalter, England, 1310–20. (BL, ROYAL 2 B. VII, F. 284R)

mino g̅l̅ośc
nim magni
catus est: eq̃
et aſcenſoze

cin mare.

...auía il ĥaroi qui oît aler auant
ue ſe il i aloit de moxt naurroit garant
fu haute la roche 9 la poit choiſir
bien de iiij lieues ne vous en quier mentir
ncoxe iporrîes autre merueille oir
i poiſſies romture ne veoir ne ſentir
uant il oxent fait lueure treſtout a loz pleſir
un tout ſeul chapitel le font deſus courir
oiſel de fin ox poz cel oeure acomplir
ont ſus le chapitel par grant enging tenir
chalemel dargent li font du bec iſſir
uel que vent que i entre quant il i puet ferir
reſtous autres oiſiaus fait cele part venir
uis les font pardefoxs tout de fin ox bzunir
uant li ſolaus reluiſt tant le fait eſclarcir

In the sixteenth century Desiderius Erasmus wrote that just as some men do not like cheese, others do not like cats due to their occult qualities. His contemporary, Heinrich Cornelius Agrippa, claimed that cats (along with wolves and moles, among other animals) were under the influence of the planet Saturn. For this reason they were very melancholic and solitary, like the night itself.

A fifteenth-century text the *Gospelles of Dystaves* (*Distaff Gospels*) by Jean d'Arras, a collection of tales narrated by women as they sit spinning wool, talks about the weather-forecasting power of cats: 'When ye see a cat sitting in a window in the sun and she licks her bottom, and that one of her feet is above her ear, ye need not doubt that it shall rain that day.'

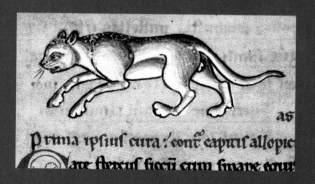

ABOVE A white male cat from *De medicina ex animalibus* (*On Medicines Made from Animals*) by Sextus Placitus. England, late 12th century. (BODL., ASHMOLE 1462, F. 58V)

OPPOSITE Apes and a cat read books with a bearded man. *Roman d'Alexandre* (*Romance of Alexander*), Flanders, 1338–44. (BODL., BODLEY 264 PT. 1, F. 96R)

The *Grandes Chroniques de France* tell of the magical powers of the black cat's skin. In 1323 the Cistercian abbey of Serquigny asked one Jean Prévost to help them discover who had stolen some of their money. With the help of Jean Persant, a magician, they placed a black cat in a chest, together with food and holy water, and buried it at a crossroads. They fixed two pipes leading from the chest to the surface so the cat could breathe. The plan was to dig up the chest after three days, flay the cat and make a magic circle from its hide. The magician in the circle would then call on a demon named Berich, who would reveal the identity of the thief. However, before this could be accomplished, the cat was heard mewing; a local justice ordered the area to be dug up and the unfortunate cat was found. All of the conspirators were discovered. Jean Prévost died in prison, although his body was burnt to ashes. Jean Persant was burnt at the stake with the same black cat tied around his neck, while the other conspirators, the abbot of Serquigny, certain canons regular and a monk of Cîteaux were degraded and imprisoned for life.

A large black cat and a mouse, with a mouse and a weasel below, accompany a bestiary text on each animal. England, mid- to late 13th century. (BL, HARLEY 3244, F. 49V)

ulib; gapiendum. que eox similes gaupe ee treate pot
ftozes depictas ponunt pulcherimas columbas. Int
rapiente uisu similes generent. Inde est qd qdam
tueri uident eiusdem animaliu uult. ut cenophalos
tes similes fetus pariant. Hanc eni feminax ee na
mente gtepiunt in grtremo uoluptatis eftu dum goti
ut: geenim animalia in usu uenario formas grtrise
sanata typis rapit senel hox in ipam glutatem. In
r. que gr diuisis nascuntur ut mulus gr equa et asino.
gr capris gr poxis. tyrius gr oue hyrto musino. gr cap

De muhione ul' cato q acute uidet τ in tenebris.

od murib; infestus
tum a captura uo
quod captet ·i· ui
nit ut fulgoxe lumi
. Unde a greto ue
urilegus bene sic

De mure qui ab humoxe a quo gignitur: dicut:

mal gretum nomen est. quicquid
latinum sit. Alii dicunt mures
te nascuntur. Nam mus terra gr humus. his in
quedam maritima augentur. que rursus in uiue
uftela animali sagaci.

s longum. nam telon gren
hec ingenio subdola in do
ii catulos genuerit de loco ad lotum tussert mina
c mures pseqt. Duo eni cattu genera sunt. Altera au
ne has gren itculas uocant. altera in domib; ob

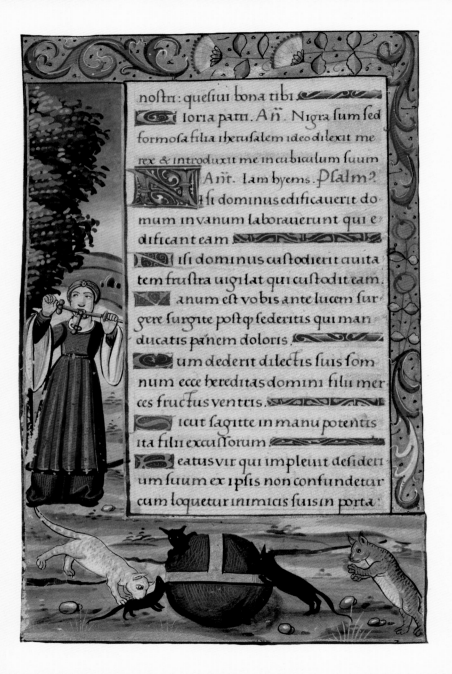

nostri: quesiui bona tibi

loria patri. Añ. Nigra sum sed
formosa filia iherusalem ideo dilexit me
rex & introduxit me in cubiculum suum
Añt. Iam hyems. Psalm?
isi dominus edificauerit do
mum inuanum laborauerunt qui e
dificant eam.

isi dominus custodierit auita
tem frustra uigilat qui custodit eam.
anum est uobis ante lucem sur
gere surgite postqz sederitis qui man
ducatis panem doloris.

um dederit dilectis suis som
num ecce hereditas domini filii mer
ces fructus uentris.

icut sagitte in manu potentis
ita filii excussorum.

eatus vir qui impleuit desideri
um suum ex ipsis non confundetur
cum loquetur inimicis suis in porta.

The cat as a creature with magical powers features heavily in medieval literature. In the Old Irish tale *Imram Curaig Maíle Dúin* (*The Voyage of Maíle Dúin's Boat*), a little cat guards treasure on a deserted island. When one of Maíle Dúin's friends attempts to steal a jewel, the cat leaps on him and reduces him to ashes.

In the Old Irish epic *Táin Bó Cúailnge* (*The Cattle Raid of Cooley*), the hero Cú Chulainn has the intriguing 'feat of the cat' among his skills in battle. In the Norse Sagas Thor is tricked by the giants, who challenge him to pick up a large grey cat. Thor is only able to make the cat lift one of its paws, as every time it is approached it arches its back and cannot be moved. It transpires that the cat is in fact a disguise for the great serpent that encircles the world.

ABOVE A cat sits holding a mouse. Book of Hours, Netherlands, mid-15th century. (BODL., DOUCE 248, F. 210R)

OPPOSITE Two large cats chase four mice. Book of Hours, France, early 16th century. (BODL., DOUCE 276, F. 53V)

In the English *Prose Merlin*, King Arthur fought a giant cat that licked its claws when they were wet with blood. The cat was found by a fisherman, caught in his net, when it was a kitten. The fisherman decided that he could use a cat in his house to get rid of mice and brought it home. He took care of the cat until one day it strangled him, along with his wife and children. The monster cat 'great and horrible' then fled to a mountain, destroying everything in its path, until it was vanquished by King Arthur.

ABOVE Pen drawing of a cat licking its paw from *De medicina ex animalibus* (*On Medicines Made from Animals*) by Sextus Placitus. England, late 11th century. (BODL., BODLEY 130, F. 90V)

OPPOSITE A small reddish-brown cat crouches with a black mouse in its mouth. Psalter and Hours, France, *c.* 1300. (BL, YATES THOMPSON 15, F. 27V)

interemptorum.

Ut annuncent in syon nomē domini: et laude eius in ierusalem.

In conueniendo ipłos in unū: et reges ut siniāt dūo.

Respondit ei in uia uirtutis sue pauatatem dierum meorum nuncia michi.

Ne reuoces me i dimidio dierum meorū: in gene

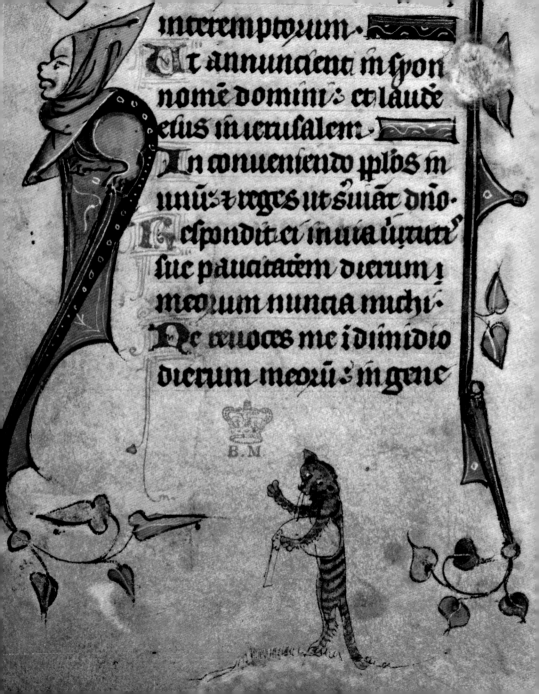

The cat was commonly associated with stringed instruments in iconography, perhaps a reference to the strings often called catgut, although they were actually made from sheep intestines. Around 1500 there was even a London inn called Le Catt cum le Fydell (The Cat and the Fiddle).

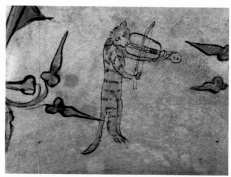

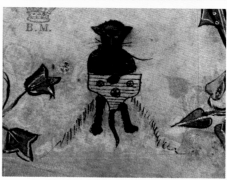

A series of animal musician marginalia: a grey striped cat stands upright (top), playing a rebec (a medieval stringed instrument); a similar cat stands on grass playing the bagpipes (opposite); a black cat sits on a green hillock, stuffing a mouse in its mouth with one paw and with the other playing a psaltery on its lap (above). Book of Hours, England, *c.* 1320–*c.* 1330. (BL, HARLEY 6563, FF. 40R, 40V AND 43V)

There are traces of medieval cats in unusual places. A copy of Astesanus de Ast's *Summa de casibus conscientiae* (*Cases of Conscience*), printed in 1472–3, has three inky cat paw prints on page 259. These were probably created when the printer laid out his printed pages on benches or table tops to dry and his cat then walked on them, smudging the ink.

ABOVE A reddish-brown cat eating a mouse. Psalter and Hours, France, *c.* 1300. (BL, YATES THOMPSON 15, F. 215V)

OPPOSITE A white cat is illustrated playing an organ. Book of Hours, France, 15th century. (BODL., DOUCE 80, F. 106V)

t secundum multitudi
em miserationum tuarum
ele iniquitatem meam.
mplius laua me ab in
uitate mea: et a peccato m

Further Reading

PRIMARY SOURCES

J.L. Baird, G. Baglivi and J.R. Kane (trans. and ed.), *The Chronicle of Salimbene de Adam* (Binghamton, N.Y.: Medieval and Renaissance Texts and Studies, 1986). [Quoted pp. 20 and 40]

R. Barber, *Bestiary: Being an English Version of the Bodleian Library, Oxford, MS Bodley 764* (Woodbridge, Suffolk: Boydell Press, 2010).

Eleanor Hull, *The Poem Book of the Gael: Translations from Irish Gaelic Poetry into English Prose and Verse* (London: Chatto & Windus, 1912) [Pangur Bán, quoted p. 31].

Albertus Magnus, *On Animals: A Medieval Summa Zoologica*, trans. Kenneth F. Kitchell and Irven Michael Resnick, 2 vols (Baltimore: Johns Hopkins University Press, 1999). [Quoted p. 47]

Patricia Terry (trans.), *Renard the Fox* (Berkeley and Los Angeles: University of California Press, 1992; first published 1983).

SECONDARY SOURCES

W. George and B. Yapp, *The Naming of the Beasts: Natural History in the Medieval Bestiary* (London: Duckworth, 1991).

D. Gray, 'Notes on some medieval mystical, magical and moral cats' in Helen Philips (ed.), *Langland, the Mystics and the Medieval English Religious Tradition: Essays in Honour of S.S. Hussey* (Cambridge: D.S. Brewer, 1990), pp. 185–202.

M.H. Jones, 'Cats and cat-skinning in late medieval art and life' in Sieglinde Hartmann (ed.), *Fauna and Flora in the Middle Ages: Studies of the Medieval Environment and its Impact on the Human Mind* (Frankfurt: Peter Lang, 2007), pp. 97–112.

S. Lipton, 'Jews, heretics, and the sign of the cat in the Bible moralisée', *Word and Image* 8:4 (1992), pp. 362–77.

B. Newman, 'The cattes tale: A Chaucer apocryphon', *The Chaucer Review* 26.4 (1992), pp. 411–23.

E. Power, *Medieval English Nunneries, c. 1275 to 1535* (Cambridge: Cambridge University Press, 1922).

Brigitte Resl (ed.), *A Cultural History of Animals in the Middle Ages* (New York: Berg, 2007).

J.E. Salisbury, *The Beast Within: Animals in the Middle Ages* (London: Routledge, 2010).

First published in 2011 by
The British Library
96 Euston Road
London NW1 2DB

This edition published in 2019

Text © Kathleen Walker-Meikle 2011, 2019
Images © The British Library Board and other
named copyright holders 2011, 2019

British Library Cataloguing-in-Publication
Data
A catalogue record for this book is available
from the British Library

ISBN 978 0 7123 5293 2

Designed and typeset by Andrew Barron
Printed in Hong Kong by Great Wall
Printing Co. Ltd

Images on the following pages © The
Bodleian Library: 2, 5, 12, 14, 17–19, 24–6,
30, 31, 41, 43, 46–50, 52, 54, 59–61, 66,
68, 76, 77, 80–82, 87.

Note from the author: The spelling of many
words in the quoted Middle English texts has
been modernized.

PAGE ii: Book of Hours, England,
c. 1320–c. 1330. (BL, HARLEY 6563)

COVER: Roundel with three cats. England,
mid-13th century. (BL, HARLEY 4751, F. 30V)